Dior

© 2004 Assouline Publishing
601 West 26th Street, 18th floor
New York, NY 10001, USA
Tel.: 212 989-6810 Fax: 212 647-0005
www.assouline.com

Photographs by Willy Maywald: © Ass. WILLY MAYWALD/ADAGP, Paris 2001.

Partially translated from the French by Molly Stevens, The Art of Translation.

Color separation: Gravor (Switzerland)
Printed by Grafiche Milani (Italy).

ISBN: 2 84323 676 2

Dior

MARIE-FRANCE POCHNA

"Fashion is an expression of faith. In this world of ours that seeks to give away its secrets one by one, that feeds on false confidences and fabricated revelations, it is the very incarnation of mystery, and the best proof of the spell it casts is that, now more than ever, it is the topic on everyone's lips."

Christian Dior et moi by Christian Dior, Librairie Amiot, Dumont, 1956

a swirling skirt twenty meters in circumference, hat tipped over one eye, haughty bearing. No dream, when it first appeared on February 12, 1947, but femininity incarnated; flirtatious, voluptuous, a blend of the outrageous and the elegant: a true Parisian allegory. This was the New Look, fifty years ago, the masterstroke that won back for Parisian couture the place it had lost during the war. Even now, many years later, the name Dior has lost none of its luster. Though other masters of couture may be synonymous with a particular style, Dior expresses all the magic of fashion, its ability always to start afresh. It was Dior who brought about that marriage of the modern and the miraculous by transforming the role of haute couture. Until then, it was confined to a privileged minority; thanks to him it became the means to fulfilling the dreams of millions of women. "Women, with their sure instincts, realized that my intention was to make them not just more beautiful but also happier," said Dior. A businessman as well as poet, he made fashion responsible for expressing society's desires, and showed it how to communicate universally, establishing the democratic course of its future development.

His was a unique destiny, which his friend Jean Cocteau foresaw in his name: "that magic name made up of the name of god and gold" (god/gold = Dieu/or = Di/or). The pun concealed a flattering

reference by the surrealist poet to the "golden fortunes" that would be Dior's lot. For fifty years, that name has been synonymous with luxury and high fashion. It has held its own against every other label, and now stands for a sort of perfection of discretion, elegance, femininity, and taste. Where did it come from? What is its essence? Why does it continue to inspire today's designers? To find the answers, we must look at the life and work of Christian Dior. In everything he did, Dior was a true artist, although his progress was far from smooth: fate, accident, and luck all played their part. And there was absolutely nothing to indicate that Christian Dior would make a career in fashion. Rather the reverse—which may explain the importance he accorded, during his lifetime, to cards, astrology, and the many throws of the dice.

He was born on January 21, 1905, in Granville, a Channel port that had lost its importance as a fishing center, and was now an elegant bathing resort. The family represented the very best of the solid bourgeoisie of the day: his uncle, Lucien Dior, was a minister, his father, Maurice Dior, grew ever richer as his fertilizer business prospered, and his elegant mother, Madeleine, made it her business to spend their wealth on making life as agreeable as possible. The future of the young Christian Dior appeared well mapped out. He was the second in a family of five children, reared on sound principles, and surrounded by nannies. But in some ways he was unusual. He soon showed a genuine curiosity about the plants and flowers growing in the garden that Madame Dior created in Granville, and which became her masterpiece. And above all, it was clear that he had a precocious gift for drawing, which he demonstrated at carnival time. Granville was famous for its carnival, and the young Christian, carried away by the flower-decked floats and processions, excelled in devising fancy dress costumes. What might seem merely a childish game can now, in hindsight, be seen as a sign of real artistic gifts. But no one close to him

was anxious to encourage leanings that did not at all correspond to their notions of a respectable career for a young man in standing. And when Christian Dior announced after his *baccalauréat* that he wanted to go to art school, he was met with a firm refusal. It was the first real confrontation, but amicable, for Dior belonged to a generation that accepted the need to compromise with parental wishes. He agreed to enroll at the École libre des Sciences Politiques in Paris (his mother longed to have an ambassador for a son), but made no promises that he would not play truant.

dior was drawn to the bohemian side of Paris life; it was here, as it turned out, that he would receive his true education. There was the Bœuf sur le toit, the Russian Ballets, the exhibitions of abstract art, places where an elegant public mingled with the artistic community dominated by Jean Cocteau. Dior became part of a small group of talented young rebels, future luminaries all: painters like Christian Bérard, musicians like Henry Sauguet and Les Six, writers like Maurice Sachs. Dior himself studied music, learned about painting, flirted with the avant-garde. In the end he failed his exams at the École libre des Sciences Politiques, and his dilettante existence was threatened. His father, however, had tired of the fight and, faced with his son's passive resistance, agreed to put up the funds to open an art gallery. Christian's happiness was short-lived. In 1931, a series of bad investments swallowed up his father's entire fortune. There was a second confrontation, this time more acrimonious. The days of gilded youth were over: the time had come for Dior to earn his living.

It may not have seemed so at the time, but this cruel blow was the means by which Christian Dior eventually came into his own. Granted, he lived through some dark years in the meantime, scouring the small ads for jobs, and as we could say today, "of no fixed address"—which meant staying with friends and doing a flit, eating every second day, and winding up with tuberculosis. But at the end of it all, he was to recover the abilities he had let slip. One day, when he was in the depths of despondency after failing to get any of a number of jobs, a friend working in couture suggested he try sketching some designs. When they found favor, Dior applied himself further and took lessons, but his drawings already possessed a strange ability to capture life and movement, so that you could almost imagine the woman wearing the garment. After selling his designs all over the place for two years, he was taken on as a designer by Piguet. At that moment came the outbreak of the Second World War. This was a new trial to bear, but a collective one. Dior sought safety with his family in Callian, in the Var. When he returned to Paris, he found that his old job with Piguet had been filled, but was taken on by Lucien Lelong. There, gradually, the creative artist blossomed, and he began to chafe at playing a subordinate role. Dior was 40. When he looked around, he saw that all his friends were successes. Bérard was the toast of Parisian high society, and Pierre Balmain, his fellow disciple at Lelong, had just made a splash by launching his own couture house. It was high time to leave the nest.

After so many years of false starts and tentative beginnings (years when his talent was maturing and his true vocation emerging without his recognizing it), Dior's career suddenly took off. By chance he met the textile magnate, Marcel Broussac, one of the most powerful men in France, famous for his newspapers and his racing stables. Dior knew how to be persuasive. At the end of the

interview, and against all expectations, the cotton king declared himself willing to put up the money for Dior to open his own fashion house.

However difficult it may have been to imagine that a new fashion house, opening in the middle of a period of austerity and real poverty, could possible rise to become number one in the whole world, the moment had come for Dior to follow his star. Had the fortune-tellers he had consulted all his life not assured him that success would come about through women? February 12 was the fateful day when his fortunes were transformed. "Yesterday unknown," wrote Françoise Giroud, "Christian Dior became famous overnight." The young editor of *Elle,* like all those attending the show, could hardly believe her eyes. How could anyone have the nerve to launch such a fashion? The first mannequin appeared, her whirling skirts sweeping away the ashtrays. One, two, three models followed, echoing the first. Long skirts, narrow waists, full busts, it was unheard of... The women in the audience, in their short skirts and boxy jackets, unconsciously began tugging at their skirt hems. The day was won. And before long, the battle had spread to the streets.

W hat madness had made Dior do it? How could he dare preach luxury to a country paralyzed by strikes—a quarter of a million strikers in Paris and three million in the country overall—where governments were collapsing and there were shortages of gas, coal, and fuel, and where just about everything else was unobtainable? In such circumstances, to introduce a fashion like this seemed a provocation. The reaction was not slow in coming. The newsreels showed astonishing scenes of women fighting in the street. What had happened was that in the

market rue Lepic, in the eighteenth arrondissement, housewives still dressed like paupers had lost their tempers at the sight of the first New Look frocks, launched themselves at their wearers, and actually beaten them up. The unfortunate victims were left half-naked. A most curious baptism of the fire for haute couture, which had never previously been expected to mingle with street fashion. Along came Christian Dior, and suddenly it was a fait accompli. Soon all women were rushing to buy material. The new fashion was the symbol of a return to happier times. Politics had no images to combat the general gloom, but the New Look channeled the desire of forty million French people to hold their heads high again, to be restored to the pleasures of life, love, and good health. Dior was the first to be taken by surprise. All he had done was follow his hunch: "If you are sincere and natural, the real revolutions take place without your trying."

Try or not, he succeeded in jumping an even more formidable hurdle: the Atlantic. America was to be crucial in the development of the New Look, even providing it with its name. Christian Dior had called his first collection "Corolle," but the redoubtable Carmel Snow, editor in chief of *Harper's Bazaar*, rushed to be the first to congratulate the couturier with the words: "It's quite a revolution, dear Christian. Your dresses have such a new look." The news reached New York that day. Seventh Avenue (where the fashion industry is based), having been cut off from Europe during the war, had developed independently of Parisian couture. Yet in no more than a few months it was to fall into line. At a time when Europe had relinquished its leading role in the world, the American forces that had liberated the European soil had also definitely instaured their influence. The climate was right for something of a love affair to develop between the GIs and "Gay Paree," which the former had passed through all too briefly on their way home. This infatuation had not a little to do with the speed with-hich the New Look took hold, bringing a touch of color and glamour

to the land of Uncle Sam—where even the Lucky Strike cigarette packets had turned khaki.

Part of the New Look's strange dream-like power was the way the Americans thought they were recognizing themselves in a set of images that was actually a return to the past. Dior's true genius lay in daring to move the goalposts. Not only did the New Look put an end to the ugliness of the wartime fashion of short skirts, padded shoulders, platform soles, and cauliflower hats (what women did not put on their plates, they put on their heads), Dior also broke with the heritage of prewar haute couture, a movement which, having absorbed the modernism of the twenties, was developing in the direction of an increased simplification and functionalism. Gabrielle Chanel was influential, with her masculine-style suits, in introducing a minimal form of elegance. Dior rejected all of that, seeking his inspiration in the more distant past. Plunging décolletes, wide-brimmed hats tipped over one eye, rustling skirts: it is the Belle Époque that shines through, images of the past in the misty colors of Watteau or Winterhalter.

S hould we therefore call Dior a reactionary? Of course not. No, he was endowed with the profound sensibility, intuitive understanding, and independence of vision that are the hallmarks of the true artist. "Having taste means having your taste," he said. People wanted to forget the horrors of Guernica. And with that memory, out too would go cubism, concrete, and the geometric lines and sharp angles that could only recall the bruises left by the totalitarian machine. Not permanently, of course, for fashions are constantly changing, and Picasso, Le Corbusier, and Chanel were already waiting again in the wings. Mademoiselle Chanel, in fact, had sought

safety in Switzerland, and was enraged by Dior's success. She did not return until 1954, when there had been time for the scars to heal, thanks to Dior's color and warmth, grace and opulence. That same grace was apparent in the neo-Louis XVI decoration of his mansion in the avenue Montaigne, so reminiscent of the *fin de siècle* setting of his childhood, with its woodwork of Trianon gray, small-paneled doors, parlor palms, and oval-backed chairs. And the same opulence Dior permitted himself in his second collection, which established the dominance of the New Look over the rest of fashion. The star of the show, the dress called "Diorama," was made of black wool, its skirt was forty meters in circumference, and it was of an unsurpassed stylistic fashion.

Still today that dress remains an archetype, to which fashion returns at regular intervals when sated with everything else. The eternal return to the eternal feminine: waist, ankles, breasts, gracefulness, and glamour, or in other words, the resurgence of desire for the one thing in life that does not change. Following his success, Dior was invited to the United States, and only one year later, in November 1948, he was to open Christian Dior-New York. That date was a land-mark, showing just how far he had traveled in his spectacular career for, although not as dazzling an occasion as the invention of the New Look, it represented a crucial stage in his life: the moment when he moved from haute couture to marketing clothes under his own label. It was a crucial change, and it may be seen as the foundation of the whole of the future luxury goods industry, for it was in New York that Dior transformed a craft activity into a diversified empire capable of serving as a model for the whole profession.

The designer went to the United States at the invitation of Neiman Marcus, the well-known Texas store, to be presented with their award for design. Now he discovered the vast continent, which hailed him as a star. Like a child Dior was bowled over by the sheer ease of life in a

country where even cleaning ladies went to work in a Chevrolet. But European to the core, he could not help noticing the things that were lacking in this great consumer society: a taste for luxury and a feeling for elegance. Moreover, a fierce controversy concerning the New Look accompanied him throughout his American tour. The American woman was not to be won over instantly by the new silhouette. The publicity was, as it turned out, the very thing that was needed to ensure its success. Already Dior had noticed more or less crude copies appearing in the store windows. This annoyed him considerably. There was, he declared, no question of Seventh Avenue being allowed to pirate French designs. "What we are selling is ideas," he announced. He came up with a novel and far-sighted plan: his New York subsidiary would produce models specially designed for the American market; the patterns would be sold to the stores, who would make them up following strict instructions. In the first five years of the Dior firm's existence, half its income came from the New World.

thus were laid the foundations of a commercial empire with an organizational structure that was to be transplanted to Cuba, Mexico, Canada, Australia, England, etc. The perfume "Miss Dior" was launched in 1947, followed by "Diorama" and "Diorissimo." Later creations were "Poison" in 1985, "Dune" in 1991, and more recently, "Dolce Vita" in 1995. Around 1950 Dior had said: "A perfume is a door opening on to a rediscovered world. That is why I chose to create perfumes—so that merely taking the stopper from the bottle will be enough to summon up the sight of all my dresses, and so that every woman I dress will leave behind her a wake of desires. Perfume is the indispensable

complement to the female personality, it provides the finishing touch to a dress, it is the rose with which Lancret signed his canvases." He was to grant the first licenses for stockings and ties at the same time as those for perfumes.

As it expanded inexorably, the great fashion house became within a very few years, a complex center of creativity. For the first time French notions of elegance and taste, symbolized by a label, became the basis for a vast business network. It employed 1,700 people among eight companies and sixteen subsidiaries, disseminating the brand name over five continents, but still retaining a tight hold over all its various activities. Till then no one had ever heard words like "registered trademark," "standard contract," "brand images," or "style bible." Broussac provided Dior with the administrative and financial support to put everything on a proper business looting. He gave him a talented administrator, Jacques Rouët, who was the tower of strength that provided growth. But it was Dior himself who, for example, instituted the idea of asking license-holders to pay a percentage as a form of royalty. Such success was not without its detractors; Jacques Fath and, later, Pierre Cardin, were to follow his example, but such a bold approach furrowed the brows of certain colleagues accustomed to managing their artistic heritage like a traditional family business. Was not the prestige of couture at stake? The authorities, once alerted, intervened to try to forbid Dior from issuing a license to a German manufacturer of jewelry. Dior had to defend himself. Convinced he had not done more than drag his métier out of its craft ghetto, he was quite content to be called a popularizer; he made public his opinion that the "supremacy of French quality and of [its] creative talent" could provide a new source of economic activity by commercializing a tradition of taste and elegance that was distinctively French. But the prophet received some major blows. When he approached the powers-that-be about devising

and setting up a system of legal defense against copying—which was still a huge problem—the request fell on deaf ears. The French like their couturiers to be couturiers, and their industrialist to be industrialist… With his dual personality, of creative artist and manager, Dior disconcerted more than a few of his contemporaries.

Talented young designers flocked around Dior. Pierre Cardin cut suits for the first collection; Jean-Louis Scherrer learned his craft there; Frédéric Castet, later to design the furs, was given his own atelier at the age of 24. Dior was careful about promoting his staff—another feature that shows how unusual he was in a profession where the masters jealously guarded their fame and generally took little care to groom their successors. The opposite was true at avenue Montaigne. When in 1955 the firm took on a certain Yves Saint Laurent, Dior noted his talent and was the first to encourage the design prodigy of his generation, even making him his heir apparent. It was much the same with Marc Bohan, whom Dior had noticed at Patou, and took on only shortly before his death. When that shocking event occurred in the autumn of 1957—Dior died of a heart attack while at the height of his powers—the future was already assured. For Dior had from the outset run his fashion house on proper business lines, and made plain his desire that his own know-how should be translated into standard procedures. An academy of style and taste, avenue Montaigne took on large numbers of draughtsmen, having by now become more or less the creative laboratory of an empire controlling a whole network of licenses. One person who came under the Dior umbrella in 1953 was the shoe designer Roger Vivier, already well known in the United States, who was given a window on the corner of avenue Montaigne and rue François Ier. Shoes, essential to complete the silhouette, formed part of a sophisticated ensemble, the new "Dior total look," which the couturier brought in when he added his own gloves, handbags, and jewelry to the range. A pioneer in this too, Dior opened his

Grande Boutique to sell accessories and gifts, along with everything else the empire of Dior had to offer; and he allowed free rein to the talent of his friend René Gruau, whose timeless sketches brilliantly illustrated the spirit of the Dior woman.

So it came about that, when Dior died in 1957, the mantle passed immediately to Yves Saint Laurent, whose "Trapeze" line received a rapturous reception. He was succeeded in 1960 (when he left for military service) by Marc Bohan, who achieved a perfect marriage of his own creativity with fidelity to the spirit of Christian Dior, until his departure in 1989; at that date, Gianfranco Ferré was appointed as artistic director by the chairman Bernard Arnault, who had then taken over the management of the company. The Italian designer brilliantly pursued the task of translating the spirit of elegance and perfection incarnate in the gold letters of the company's name. For the quest for perfection was a central feature of this academy of haute couture, and its educational methods had been outlined by Christian Dior in his book *Christian Dior et moi* as if to give them the force of holy writ. The various stages followed in strict sequence as though they were part of a prescribed ritual, guiding the couturier and his team through a long and serious process, from the inspiration of the first sketch, to the interaction with the skills of the ateliers, and the sessions in which a dress passed through a series of metamorphosis before emerging in its final form. And all this artistry devoted to the production of a mere 1,500 items per year. The fact that today all that skill is placed at the service of probably no more than two thousand clients worldwide has altered not one jot of the immutable protocol. The average time spent on a dress is one hundred to one hundred and fifty hours. But the collection itself is merely

the keystone of a whole empire of beauty, whose mission is to spread its artistic influence far and wide.

Dior has occasionally been criticized for doing too much, and that could certainly be said of Christian Dior the man, who was driven by a passionate need to excel himself. From 1947 to 1957, he continually sought fresh inspiration within the constraints of a style, creating two lines each year: "Corolle," "Envol," "Ailée," "Verticale," "Oblique," "Muguet," etc. Dramatic masterstrokes, all of them, for which the public waited with bated breath. The lines received write-ups in the top newspapers of the day. But from the Americans, who found it all a bit too intense, it earned Christian Dior the nickname of Dictator. What they objected to—rightly—was this abuse of power, which every season decreed a different length or a particular cut, creating an absolute furor about hemlines, and a public outcry we could scarcely conceive of today. Whether it was a good or a bad thing depends on your point of view, but it was an age when the elegant woman had to change her outfit four times a day! After 1950, the silhouette softened. The waist was relaxed in 1954 with the "H" Line, and the sack dress created uproar. None of which prevented Dior from being alone responsible for half the exports of French fashion to the United States. Above and beyond the passage of time, and social change, certain things endured: and unsullied tradition of elegance, a magnificent precision of style, a specific architecture of the silhouette—whose eminently recognizable pedigree had descended intact from its source. "The dress," said Christian Dior, "is an ephemeral piece of architecture designed to enhance the proportions of the female body." Any flirtation with or concession to the more fanciful elements in fashion was therefore prohibited.

Let us remember, it was Dior who made black a color and perfected the little black wool dress that molded the female contours as sleekly as the bodywork of a car. The suits, in which he excelled, were also

nowness that was a perfect blend of past and present. But, the Spring-Summer collection of 1997 was a new conquest, it was a key season for Parisian haute couture that opened its doors to a new generation of designers, including Jean-Paul Gaultier, Thierry Mugler, Alexander McQueen, all John Galliano contemporaries. It was a season that gave haute couture its stature back, a preeminence that the success of prêt-à-porter—and its Italian designers—tended to dwindle.

Already a star at Central Saint Martins in London where he studied, Galliano did a short stint at Givenchy before being hired at Dior—his dream come true. And with wild passion he has made that world his own. "Mad for dresses," as Dior described himself, Galliano is filled with the same fervor as his illustrious predecessor. But, because of his eclecticism, he doesn't lapse into pastiche. This is the mark of his modernity. His dazzling virtuosity, his ability to slide from one theme to the next: from Venice to Africa, from the lines of Boldini sketching the Marchesa Casati to the hieratic portraits of the Masai warriors; from the Medicis to Mexico, telling, sometimes mystifyingly, the legend of Princess Pocahontas; from Bagatelle to the Raj, from sultan to dominatrix. And these are only his first inspirations. "Every dress," he says, "contains a story with many levels." While the criteria for luxury has changed, and although haute couture no longer dresses thousands of women, Galliano has, like Dior, placed the collection at the heart of his house. For it is the collection that represents the engine that sells perfumes and accessories. It's the motor that spawns the desire of an increasingly mature clientele.

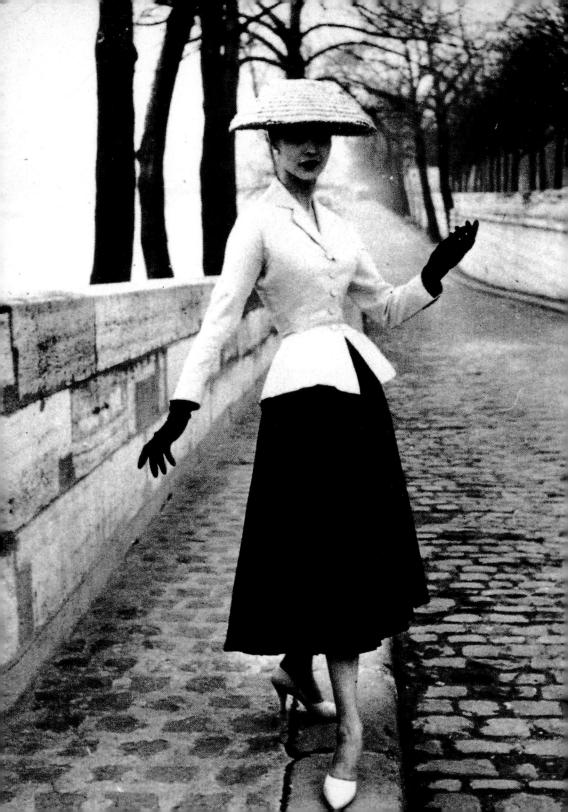

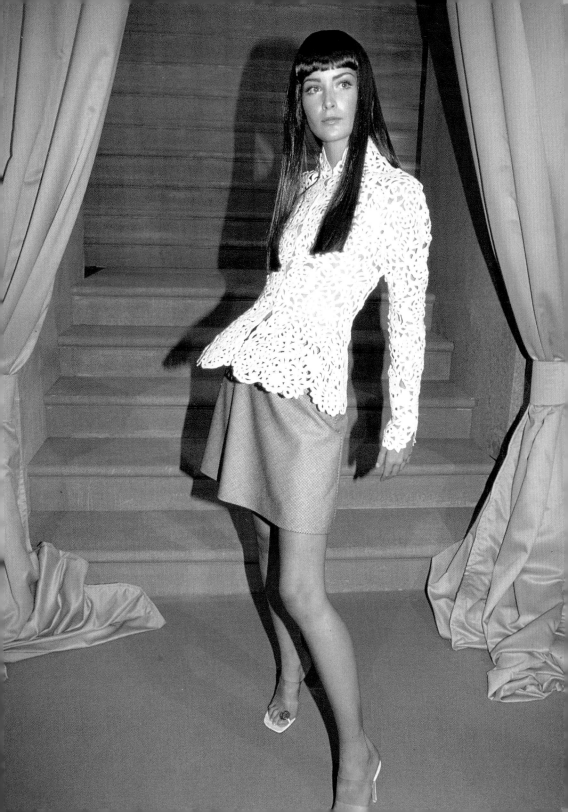

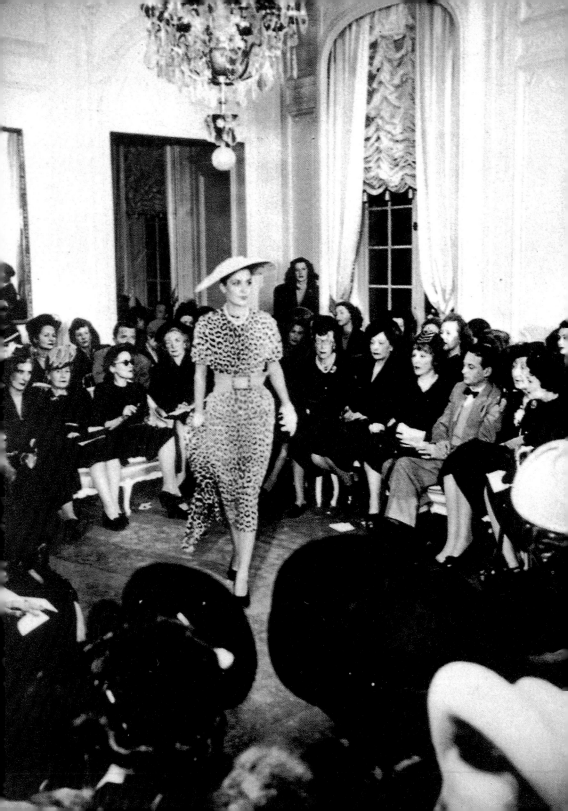

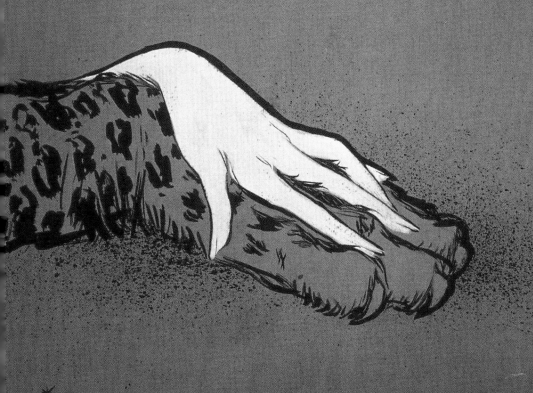

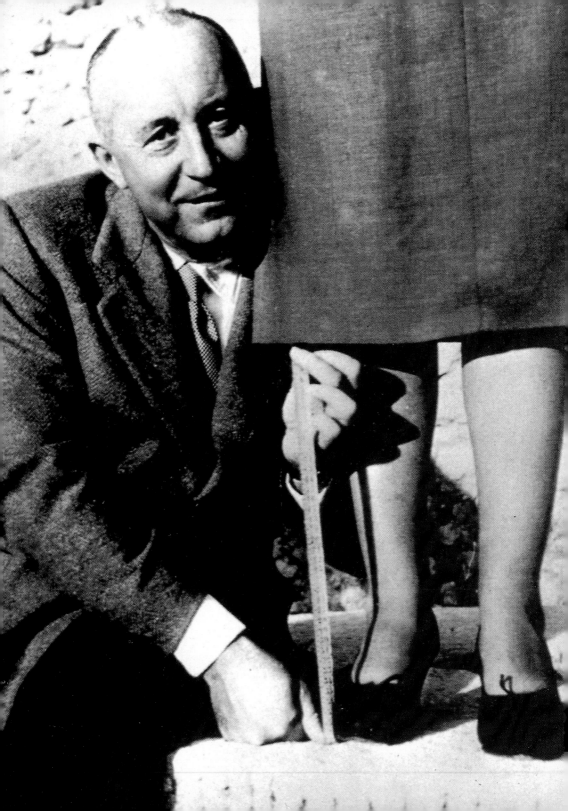

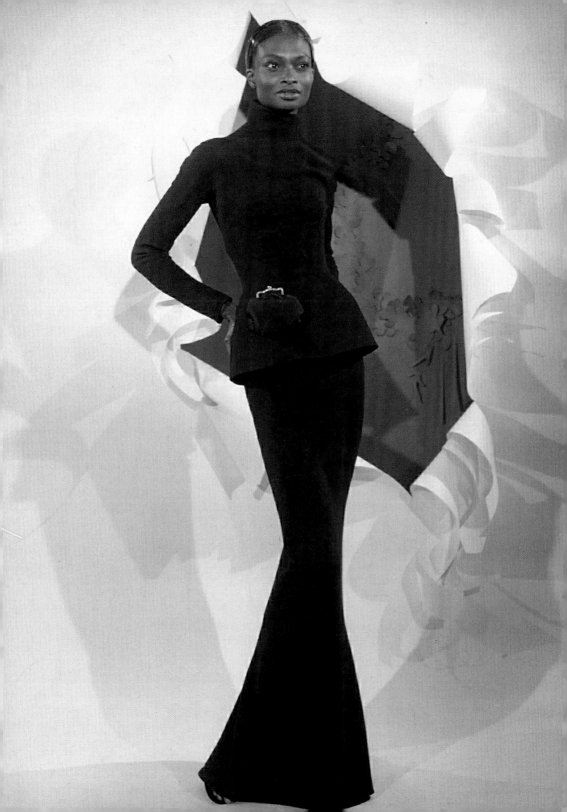

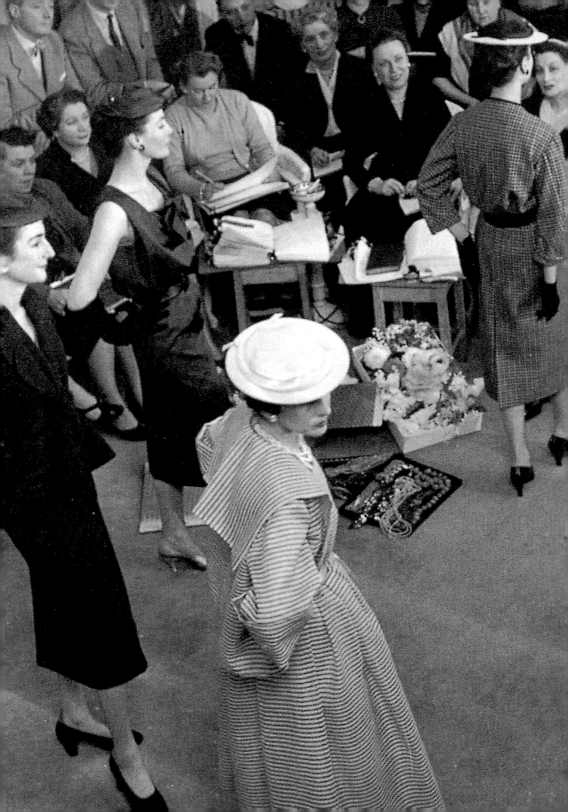

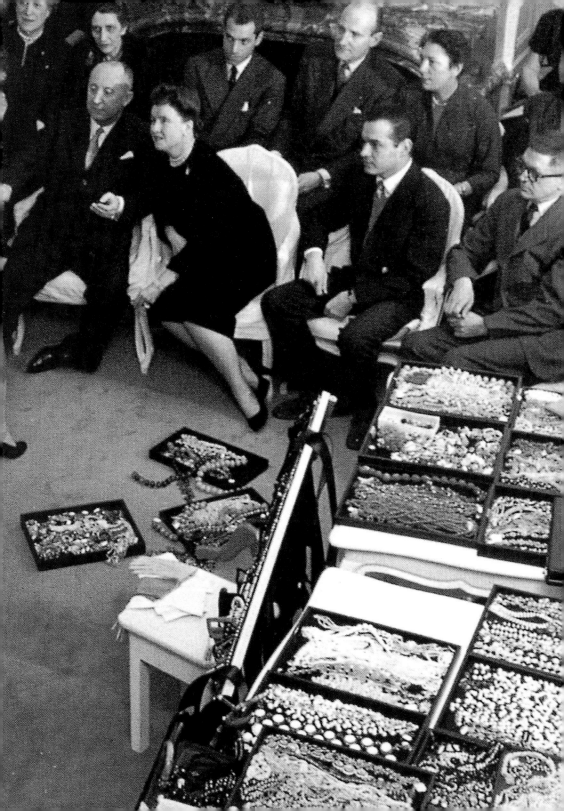

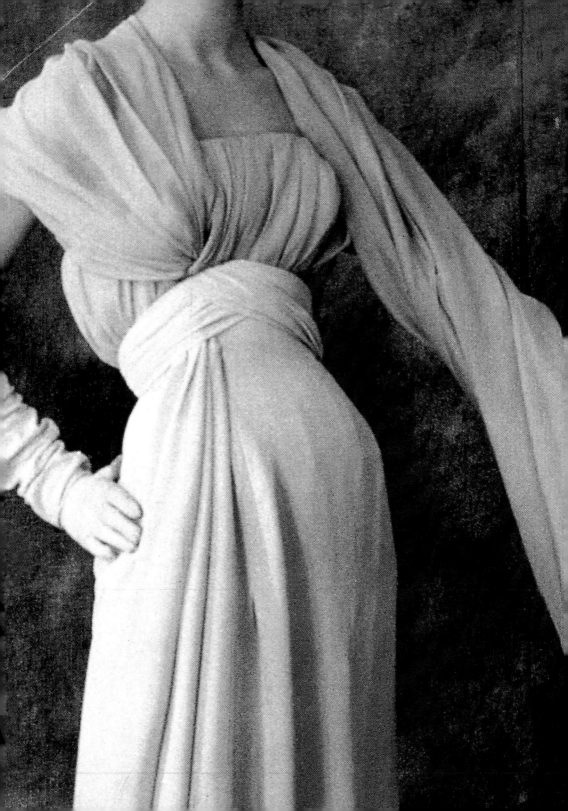

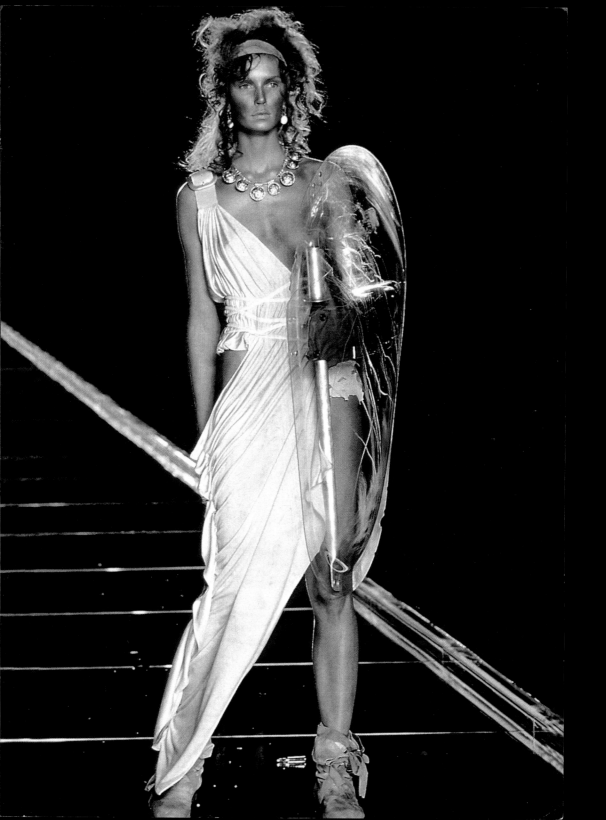

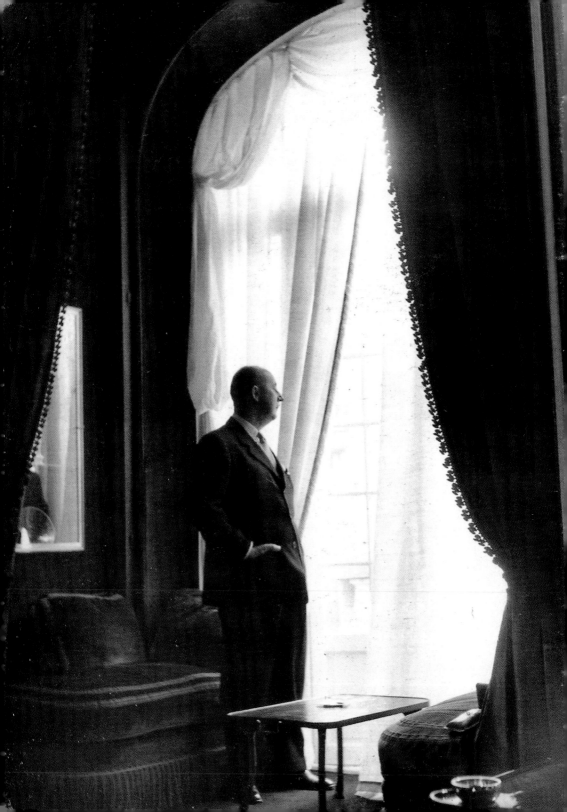

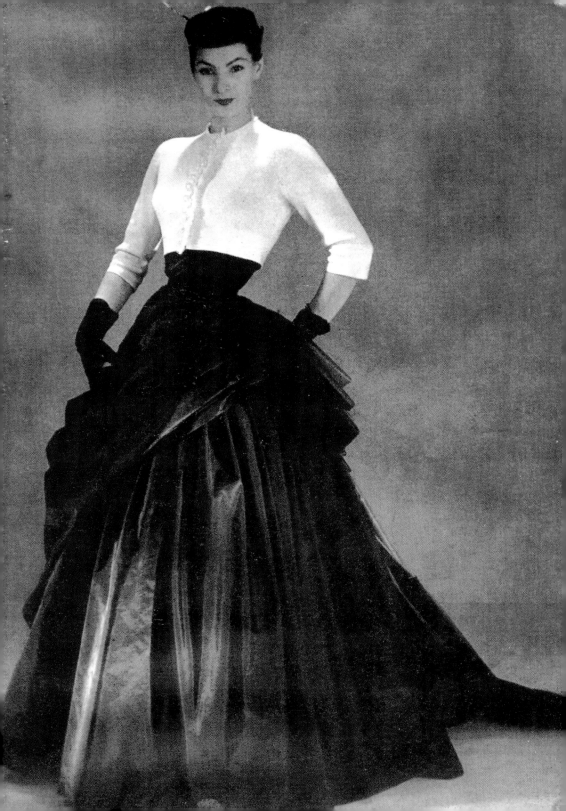

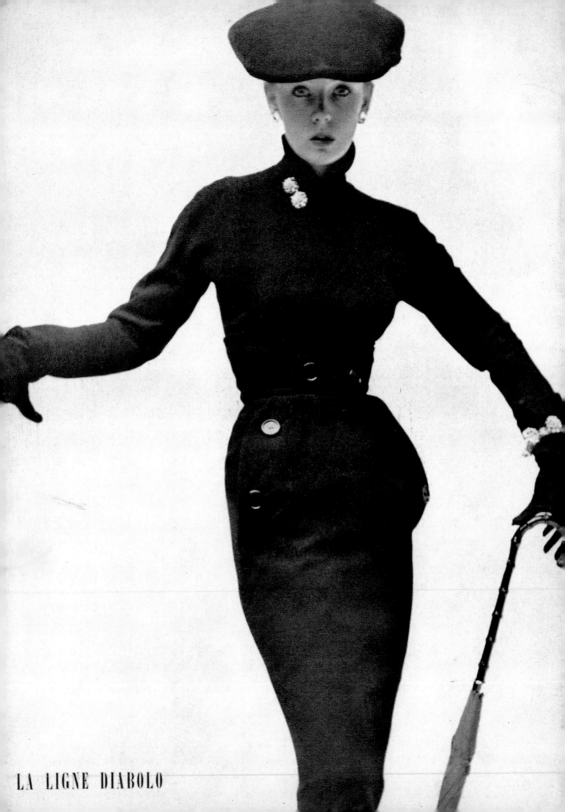

LA LIGNE DIABOLO

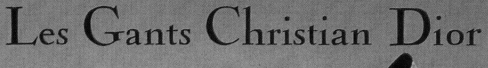

Les Gants Christian Dior

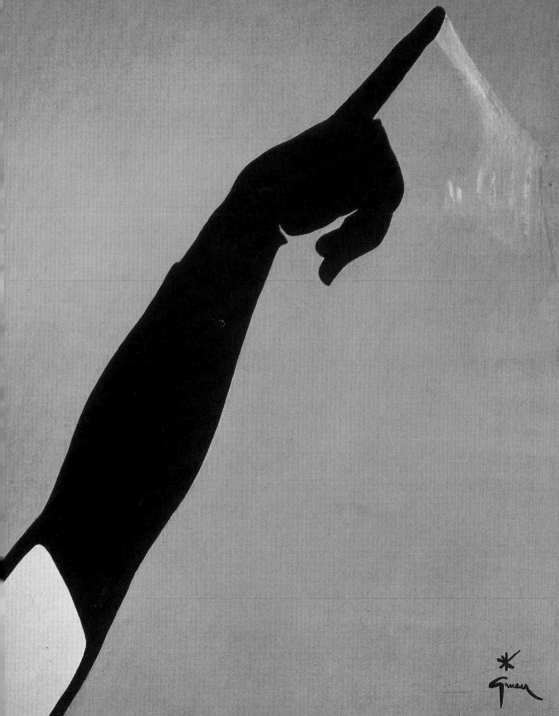

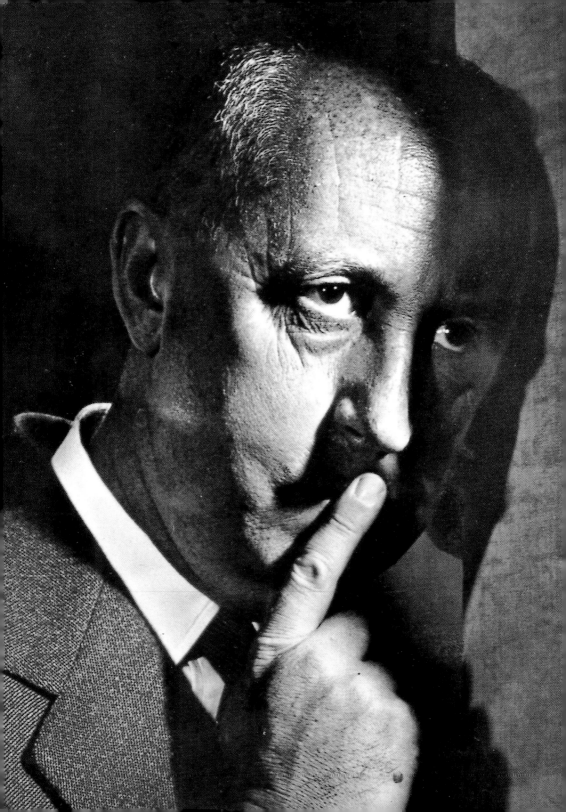

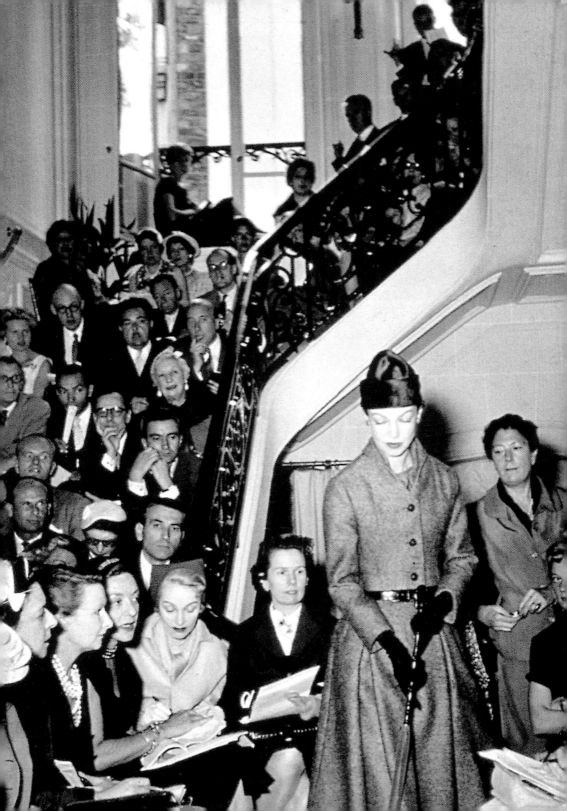

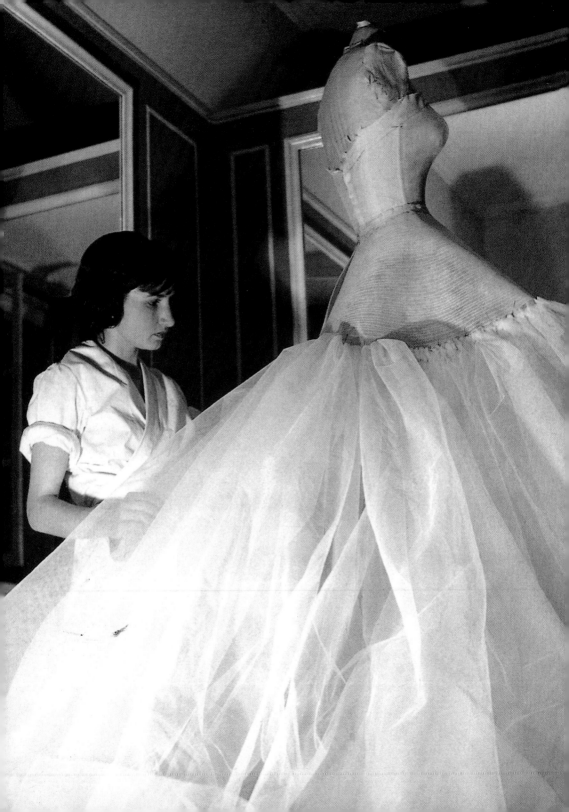

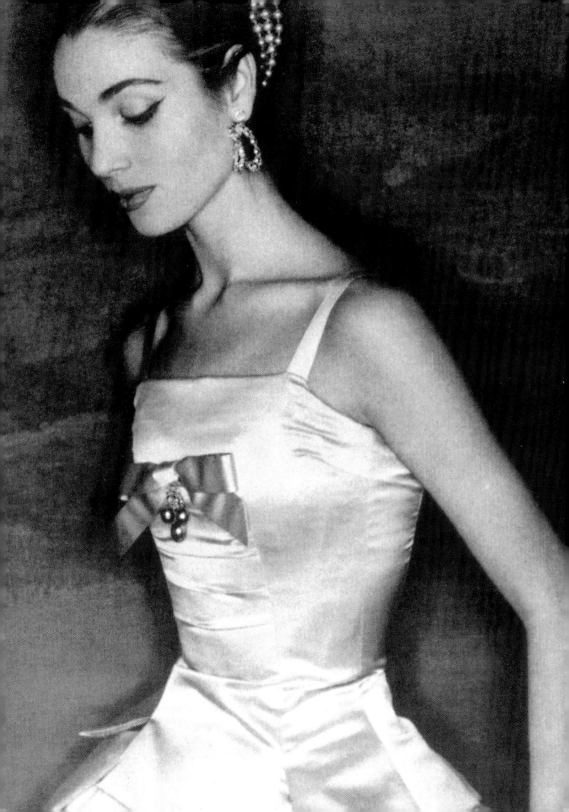

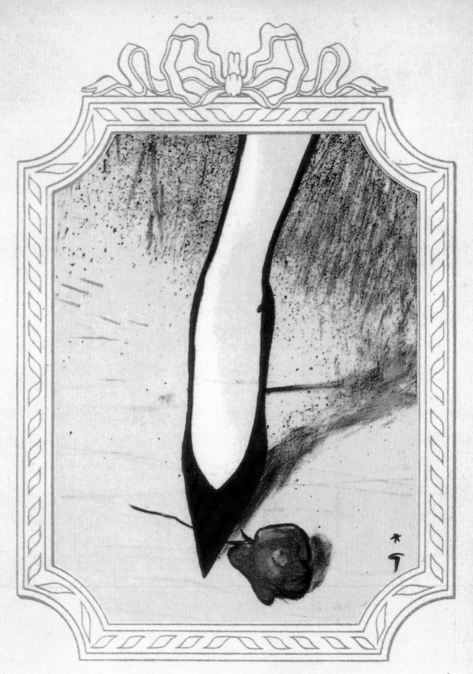

Christian Dior

Souliers créés par

Roger Vivier

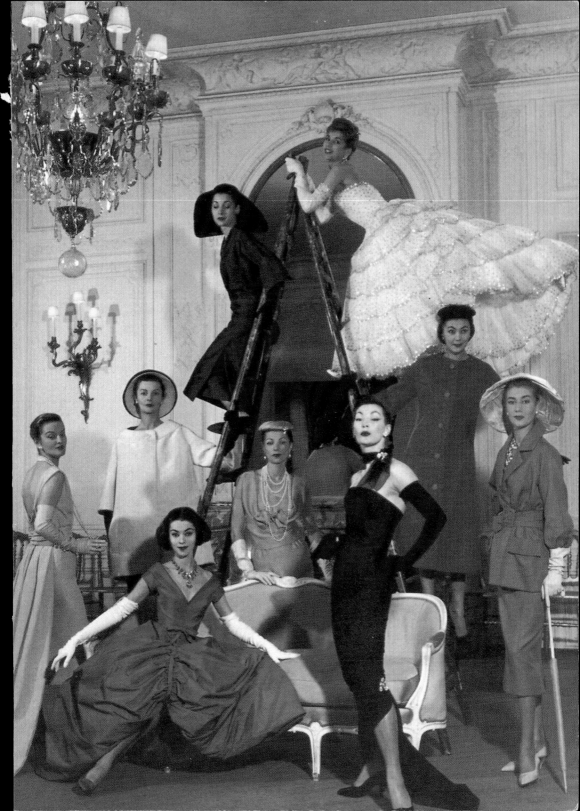

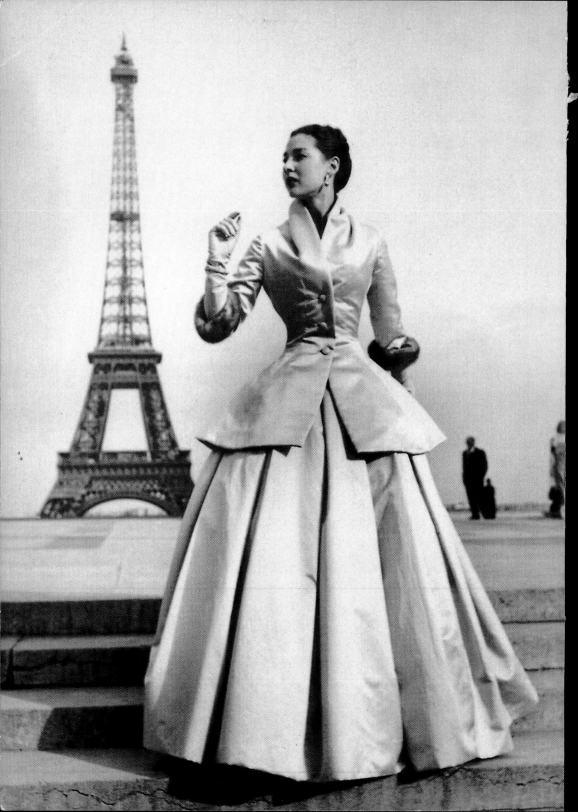

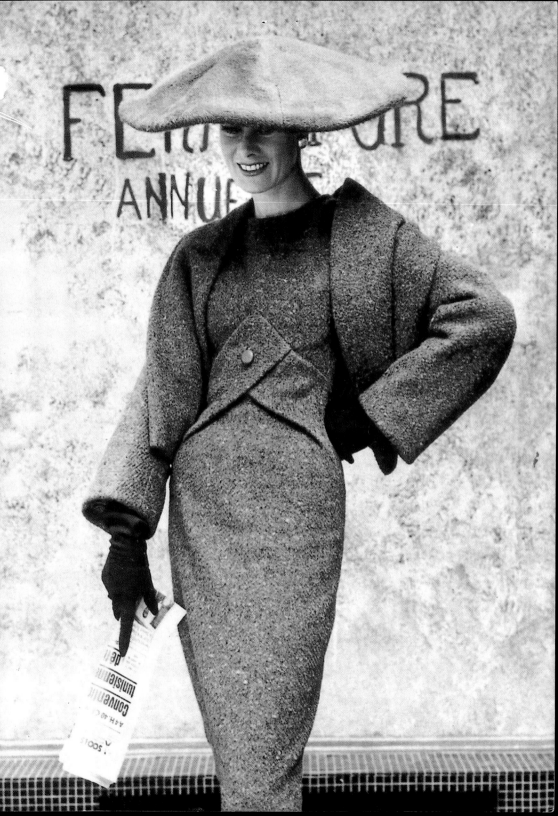

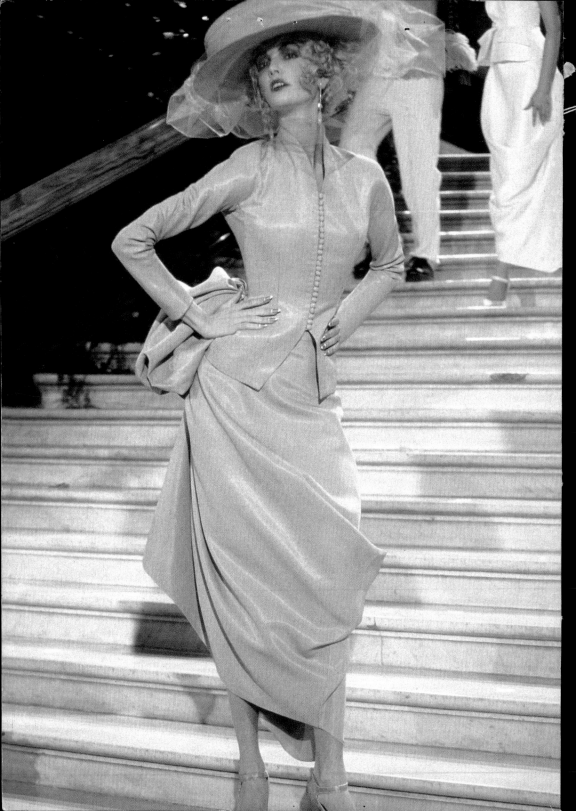

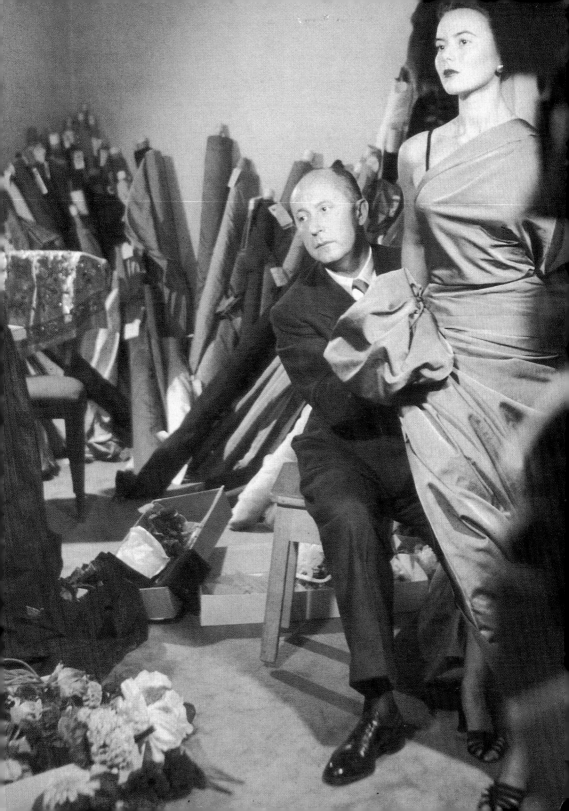

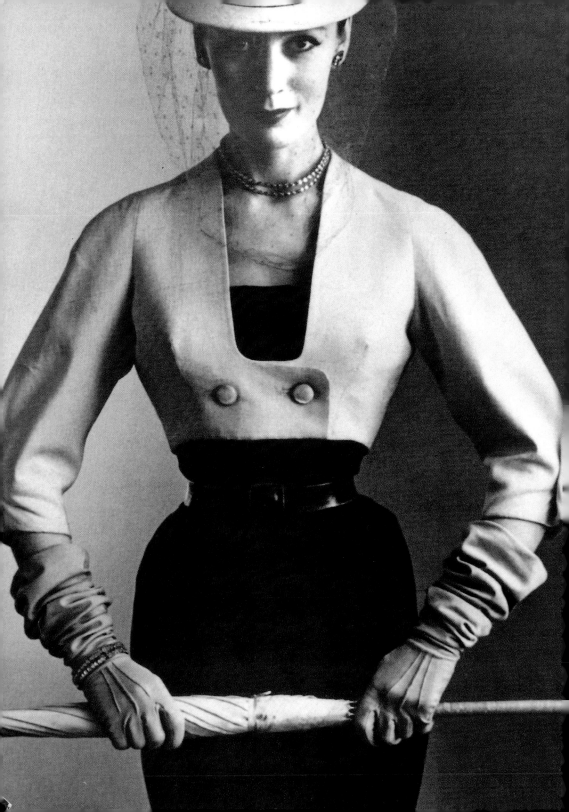

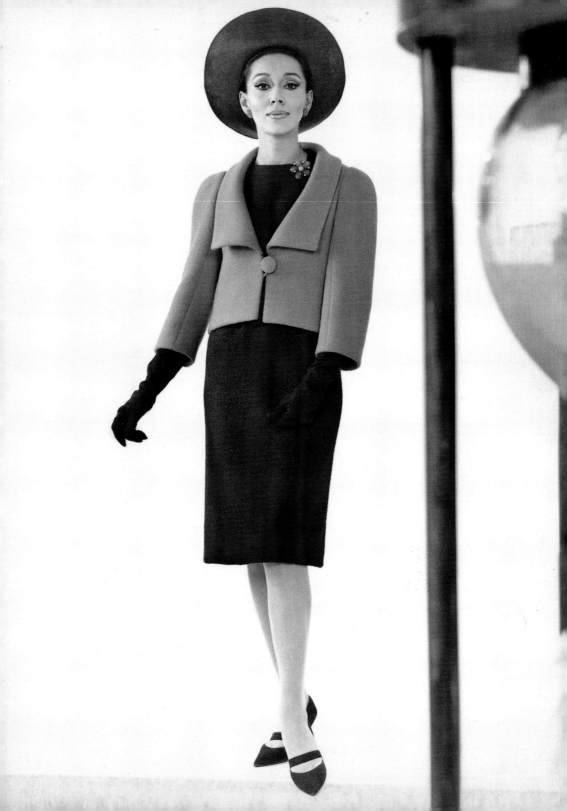

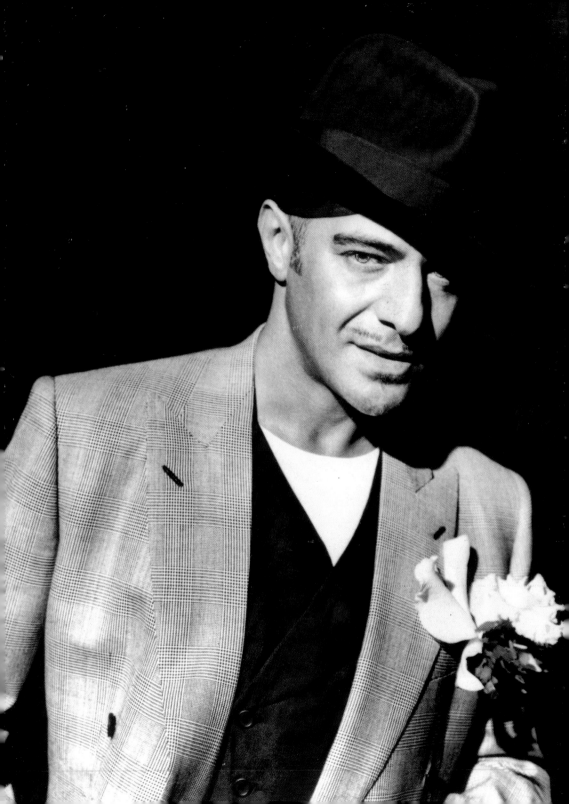

TIME

THE WEEKLY NEWSMAGAZINE

CHRISTIAN
DIOR

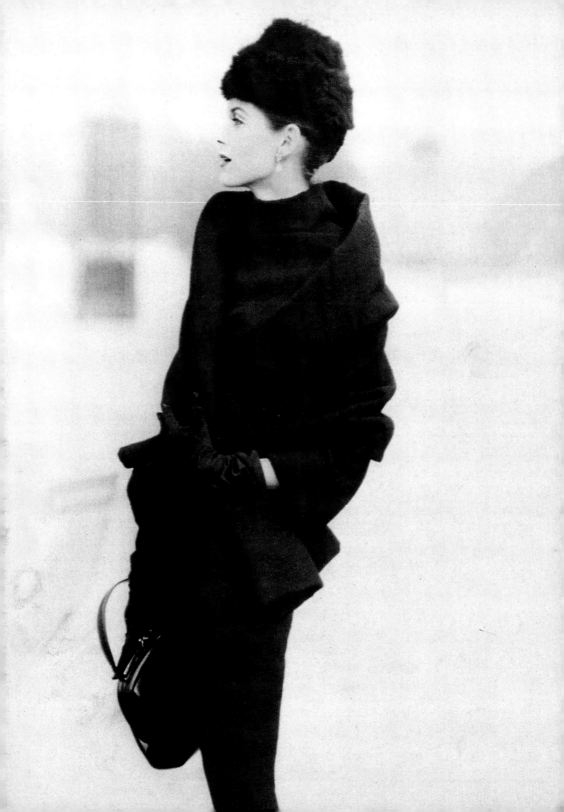

224
Lucky

225
Odile

Fourreau de
velours noir. Manches
très collantes et déco
profond.
large ceinture de sa
blanc drapé placée
au dessus de la taill
normale

M. Mathieu Saint Laurent
55.

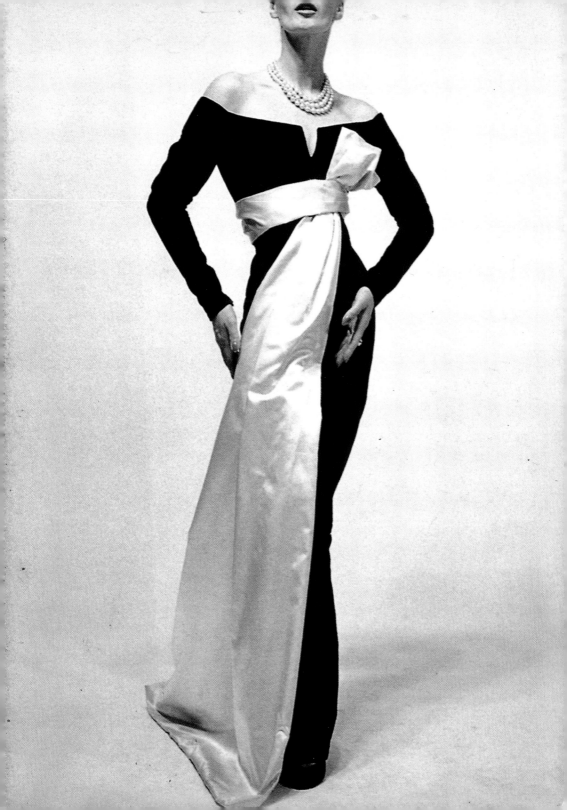

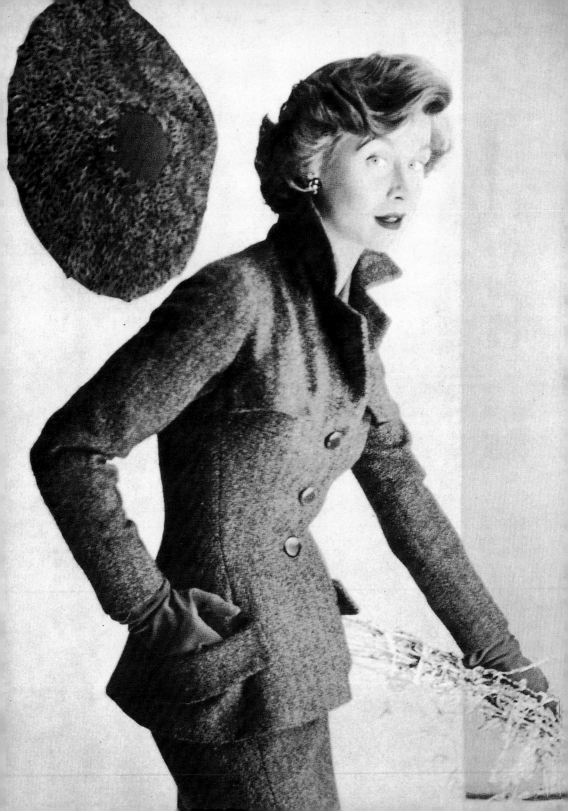

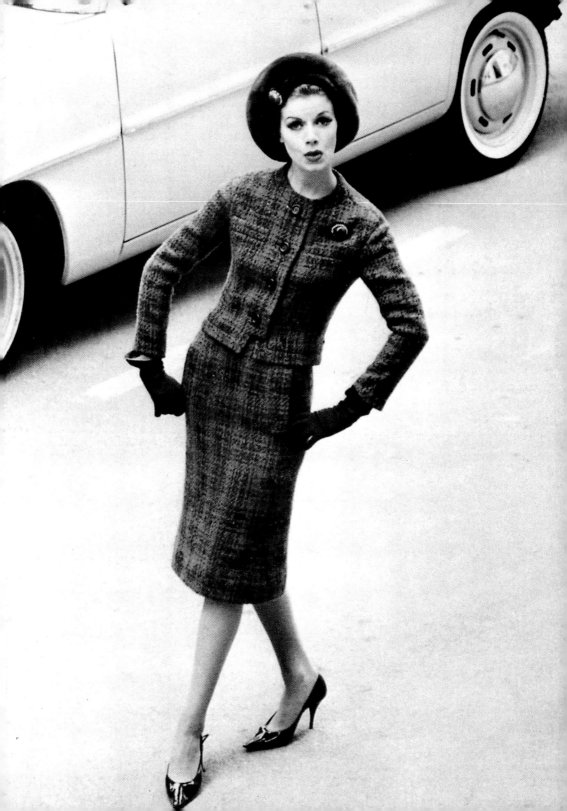

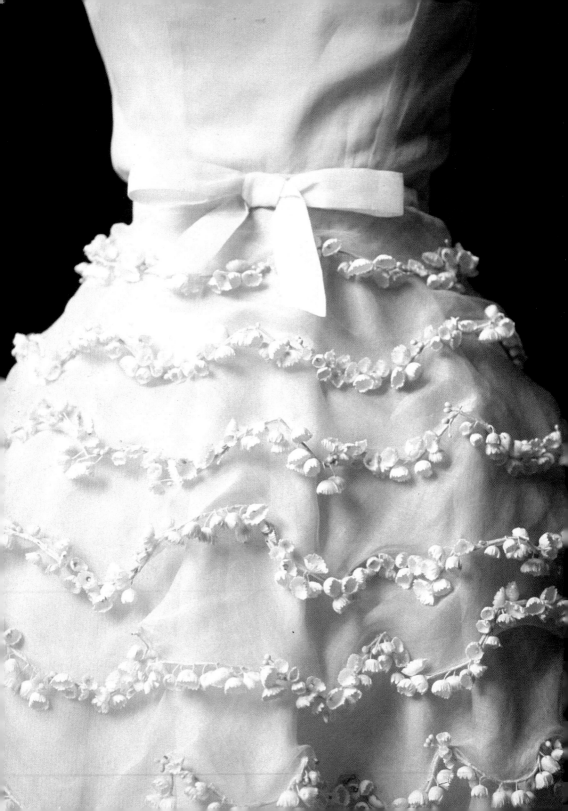

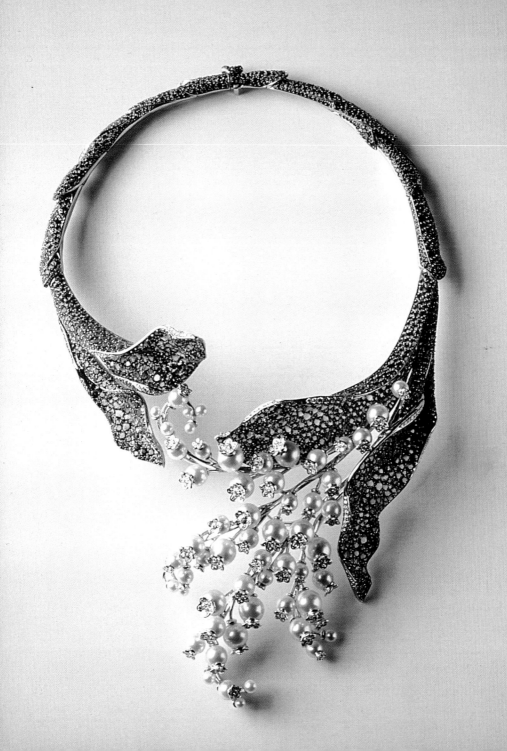

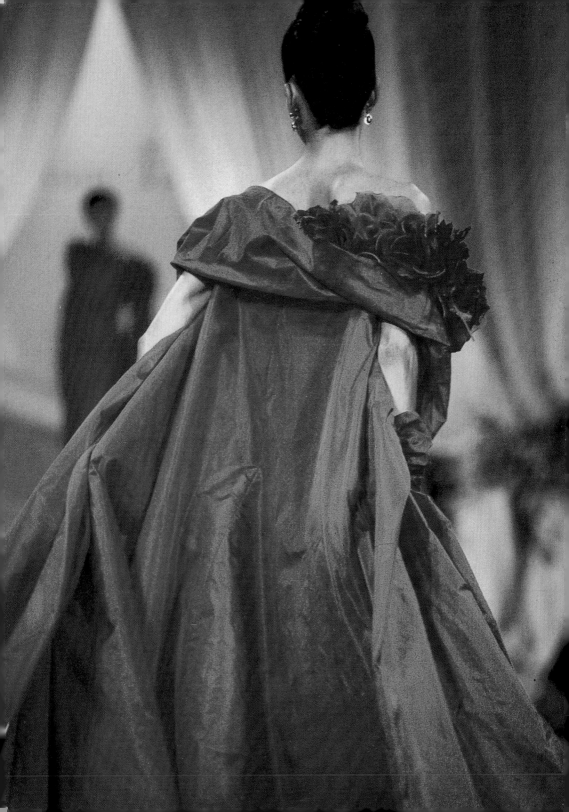

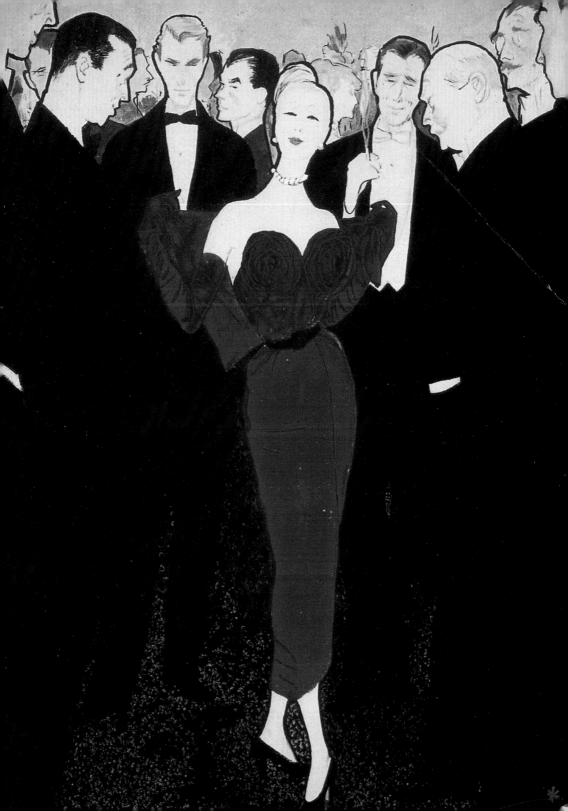

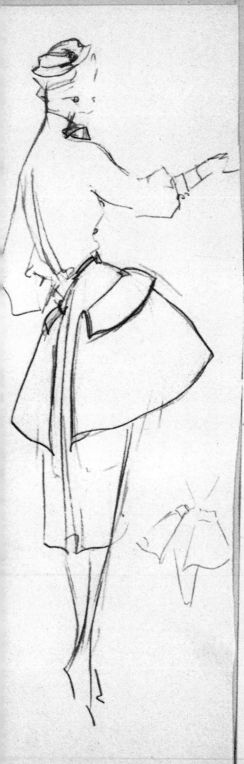
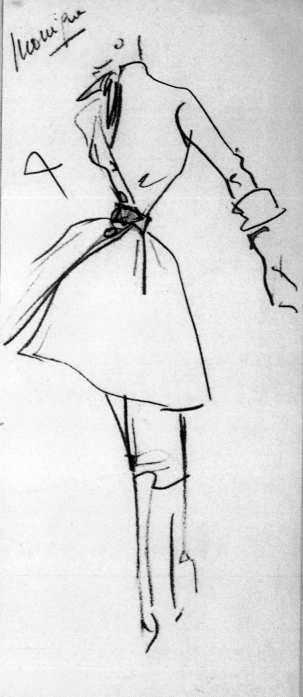

19 JUIN 1950

Christian DIOR
30, Avenue Montaigne-PARIS-8e

Croquis No 166

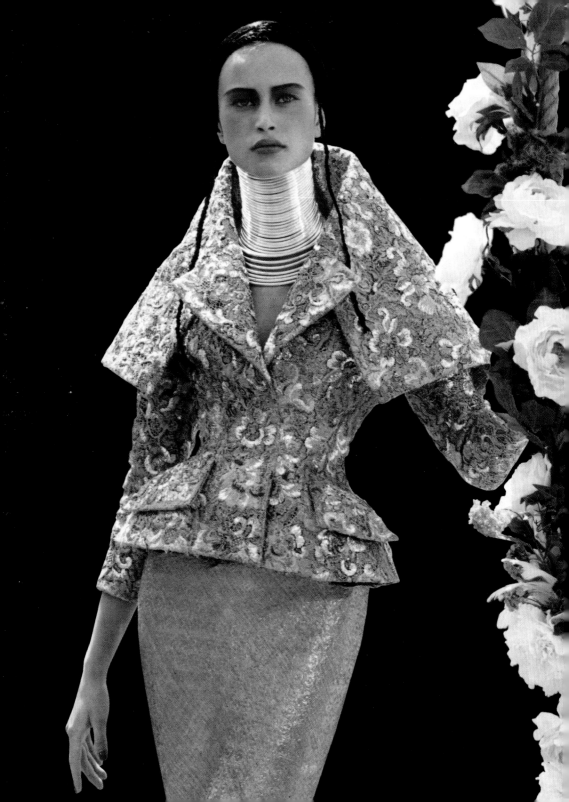

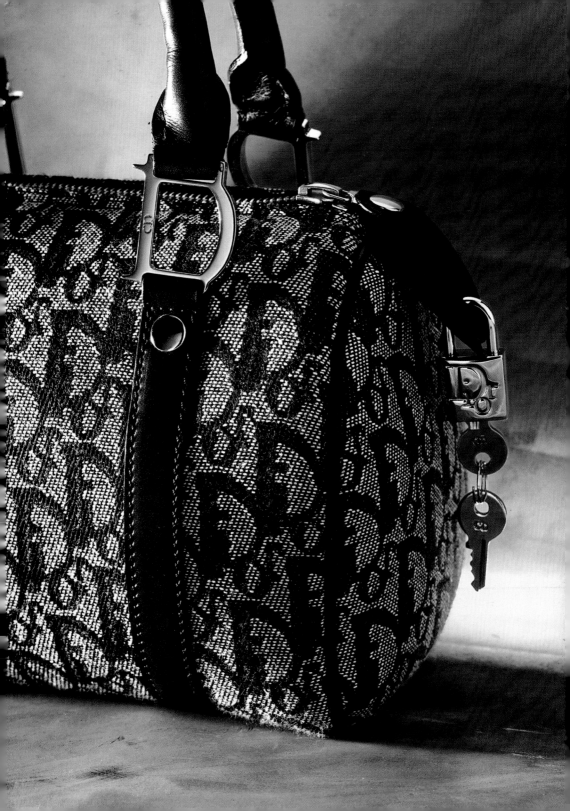

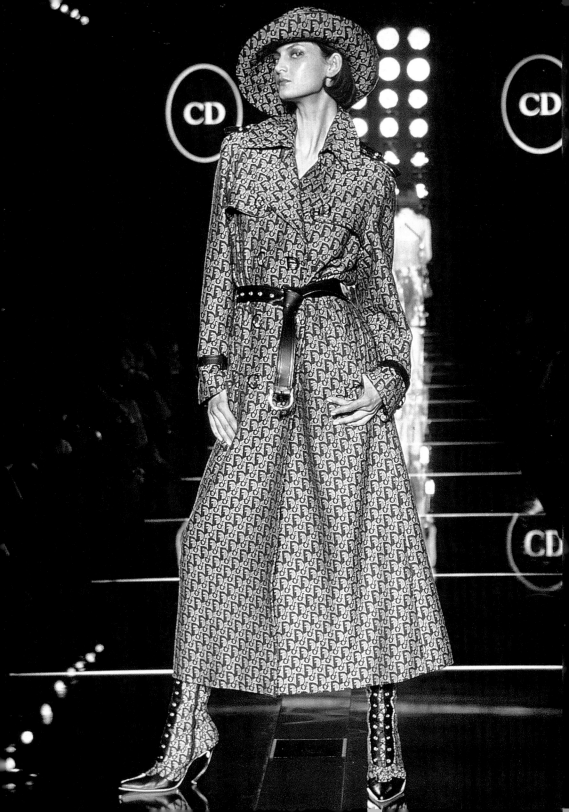

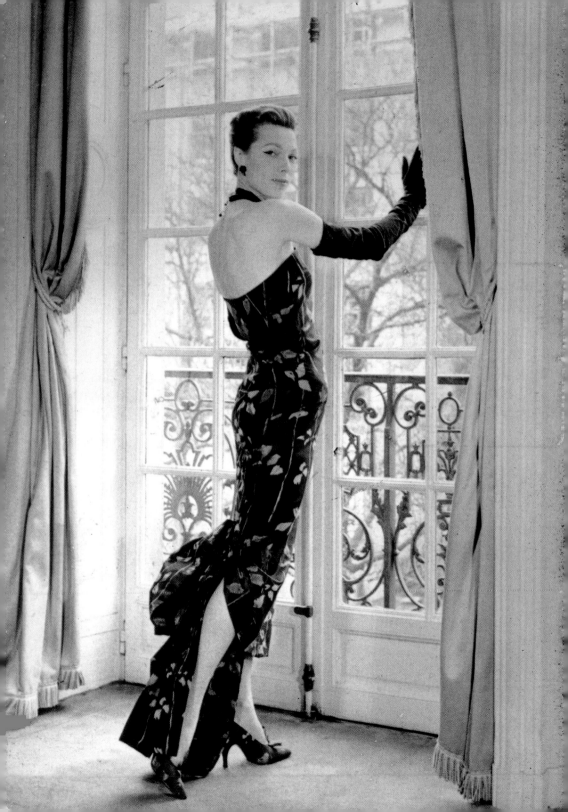

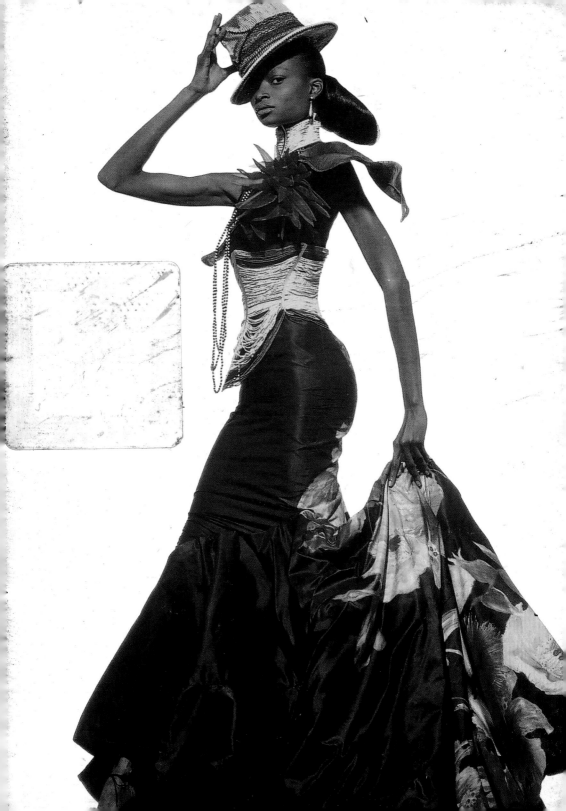

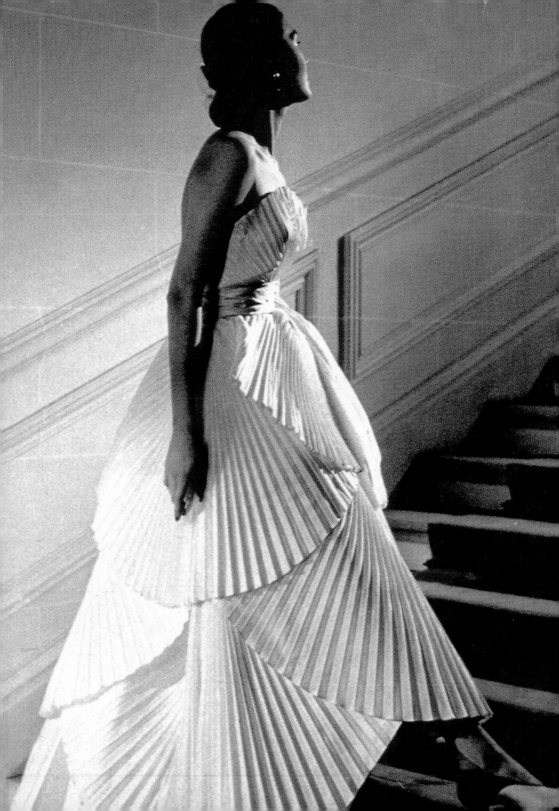

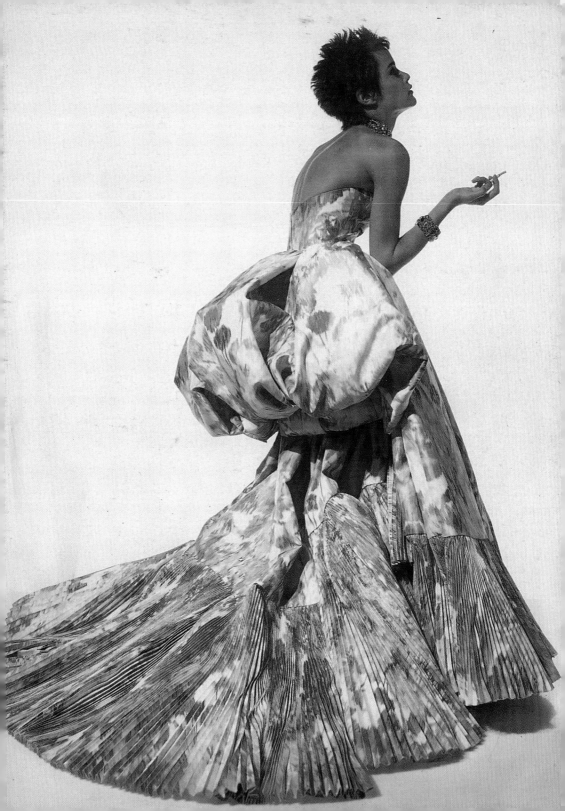

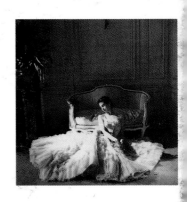
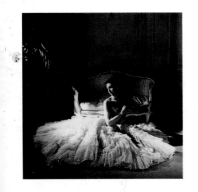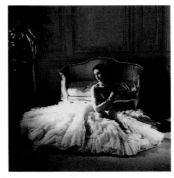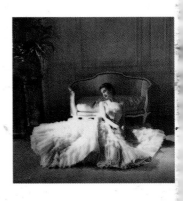
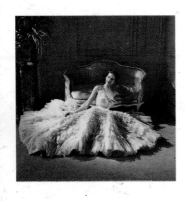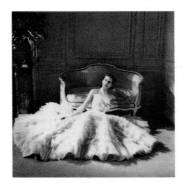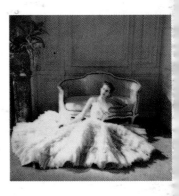

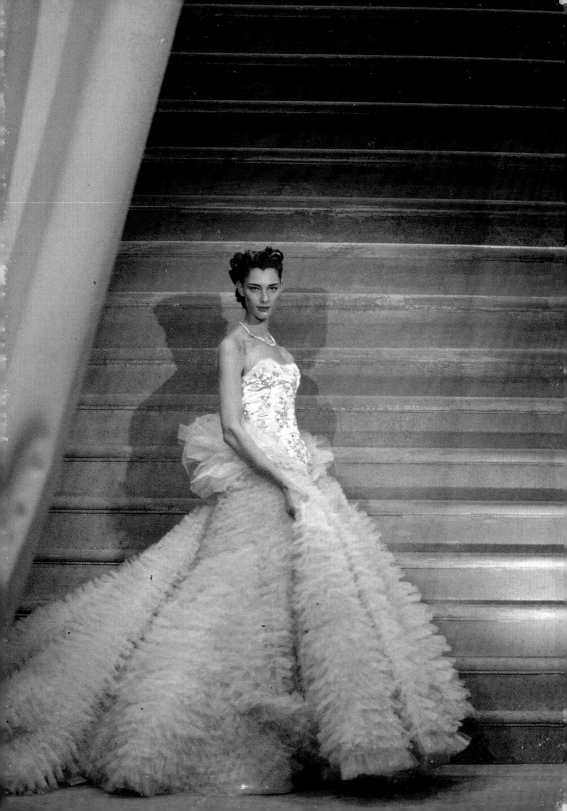

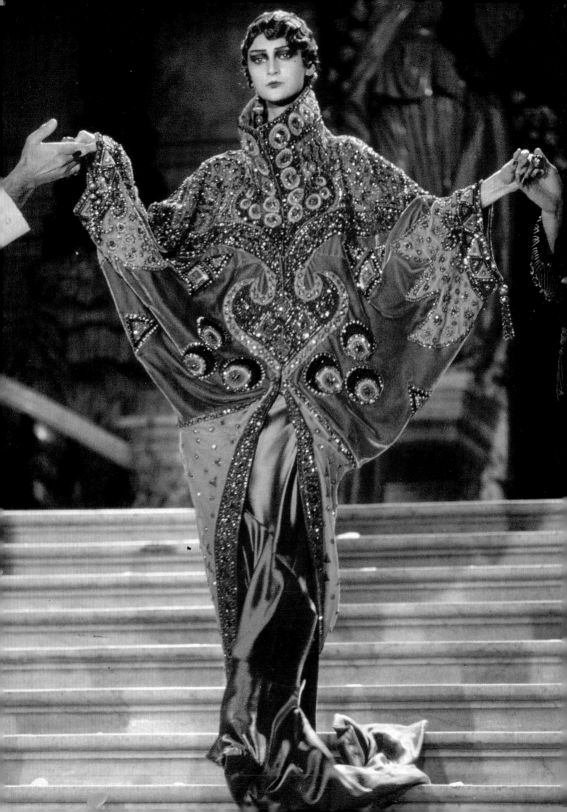

AUTOMNE·HIVER 1956

Christian Dior

PARIS

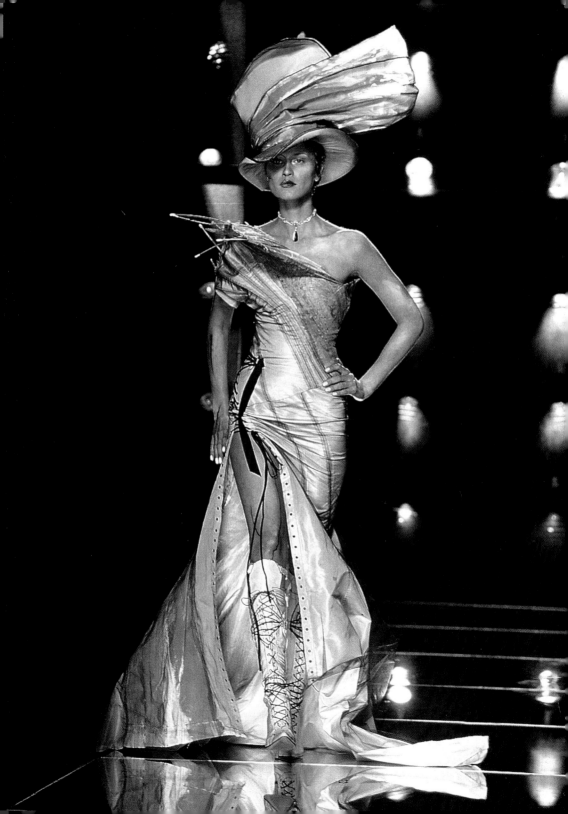

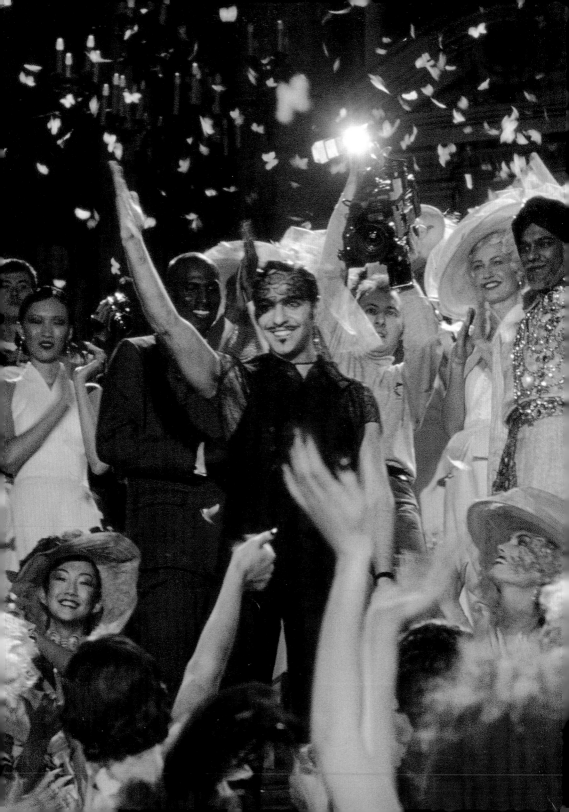

Chronology

1946 : Opening of the fashion house Christian Dior, on December 16, in a small private mansion at 30, avenue Montaigne.

1947 : Presentation of the first collection (Spring-Summer 1947). The lines "Corolle" and "8" stun the fashion world.
Dior receives a fashion award from Neiman Marcus in Dallas (USA).
Creation of the perfume christened "Miss Dior" in tribute to Dior's sister, Catherine.

1948 : Opening of Christian Dior-New York, and Christian Dior Perfumes-New York.
Christian Dior Furs opens in Paris.

1949 : Dior is the first couturier to license his products.
Launch of the perfume "Diorama."
At the "Milieu du siècle" collection (Autumn-Winter 1949-1950), more than 1,200 orders for dresses are placed in one week.

1951 : Opening of the Stockings and Gloves Department. The firm now employs a staff of 900.

1953 : Opening of Christian Dior Delman S.A.R.L, manufacturing made-to-measure shoes designed by Roger Vivier.
Frédéric Castet becomes head of the tailoring atelier.
The "Vivante" Line in the Autumn-Winter 1953-1954 collection, is baptized the "Shock Look" in England because the skirts have been shortened to 16 inches off the ground.
Creation of "Eau Fraîche."

1954 : Opening of Christian Dior Ltd., Dior's first London shop.
In Paris, the Dior firm employs a staff of 1,000, occupies five buildings with twenty-eight ateliers, and accounts for more than half of all French haute couture fashion exports.
The "H" Line, in the Autumn-Winter 1954-1955 collection, is nicknamed the "French Bean" Line, or "Flat Look."

1955 : Opening of the Grande Boutique on the corner of the avenue Montaigne and the rue François Ier.
Opening of the Gifts and Tableware Department.
Christian Dior lectures at the Sorbonne for 4,000 students.
Yves Saint Laurent is appointed to the design staff, and becomes Dior's first and only assistant.
Launch by Christian Dior Perfumes of their first lipsticks.

1956 : Creation of "Diorissimo."

1957 : Christian Dior dies of a heart attack.
Yves Saint Laurent is appointed artistic director.

1958 : Yves Saint Laurent presents the "Trapeze" Line at his first collection (Spring-Summer 1958).
Marc Bohan is appointed artistic director of Christian Dior-London.

1960 : Marc Bohan succeeds Yves Saint Laurent as artistic director in Paris.

1961 : Marc Bohan presents his first haute couture collection (Spring-Summer 1961), the "Slim Look." Liz Taylor orders twelve dresses.

1963 : Creation of "Diorling."

1966 : Creation of "Eau sauvage," the first eau de toilette for men.

1967 : First collection of women's ready-to-wear, "Miss Dior," created by Philippe Guibourgé.
Introduction of the "Baby Dior" line.
Marc Bohan designs the bridal and coronation gowns for the Empress Farah Diba, and those of her attendants.

John Galliano surrounded by models during the finale of the haute couture Spring-Summer 1998 show.
© Photo Rindoff/Garcia/Angeli.

1968 : Frédéric Castet takes over Dior Furs.

1969 : Launch of the first line of Christian Dior cosmetics.

1970 : Launch of Christian Dior Monsieur, under Marc Bohan's direction.

1972 : Creation of "Diorella."

1973 : Launch of the ready-to-wear fur collection by Frédéric Castet.
Launch of the "Hydra-Dior" beauty products.

1979 : Launch of "Dioressence."

1983 : Marc Bohan is awarded the Dé d'Or for his haute couture collection, Spring-Summer 1983.
Dominique Morlotti succeeds Gérard Penneroux as designer for Christian Dior Monsieur.

1984 : Launch of the "Eau sauvage extrême" eau de toilette.

1985 : Bernard Arnault, chairman of the Agache Group, is appointed chairman and managing director of Christian Dior.
Launch of "Poison."

1986 : Launch of the "Capture" beauty products.

1987 : To commemorate the fortieth anniversary of the Dior firm, a major retrospective is held at the Musée des Arts de la Mode: Hommage à Christian Dior 1947-1957.

1988 : A second Dé d'Or is awarded to Marc Bohan for his haute couture collection, Autumn-Winter 1988-1989.
Launch of "Fahrenheit."

1989 : Gianfranco Ferre succeeds Marc Bohan and Frédéric Castet. His first haute couture collection "Ascot-Cecil Beaton" (Autumn-Winter 1989-1990) wins the Dé d'Or.
Launch of the "Poison" eau de cologne, and of the "Icônes" beauty products.

1991 : Launch of "Dune."

1992 : Patrick Lavoix is appointed artistic director of Christian Dior Monsieur.

1994 : A major retrospective entitled "Christian Dior, The Magic of Fashion," recounting Dior's ten years of design, is held at the Powerhouse Museum, Sydney, Australia.

1996 : Fiftieth anniversary of the Dior firm.
On October 14, John Galliano is appointed artistic director of the women's wear collections.
On December 9, Princess Diana opens the Christian Dior exhibit at the Metropolitan Museum of Art, in New York.

1997 : The first haute couture and ready-to-wear collections created by John Galliano mark the rebirth of Dior.
Lauch of "Dune" for men.
Opening of the Dior Museum in Granville, in the hometown house of the designer.
The Boutique situated avenue Montaigne reopens after having been renovated by Peter Marino.

1998 : Opening of the Saint-Germain-des-Près and Faubourg-Saint-Honoré stores, in Paris.

1999 : Launch of the new jewelry line designed by Victoire de Castellane.
Opening of the first jewelry store, at 28, avenue Montaigne in Paris.
Opening of a new Dior store in New York, on 57th Street, in the LVMH Tower designed by Christian de Portzamparc and opened by Hillary Clinton.
Launch of "J'adore."

2000 : Hedi Slimane is appointed as artistic director of Christian Dior Homme.

2001 : Launch of "Higher," a new male fragrance.
Reopening of the men's wear store situated avenue Montaigne.
Opening of a new jewelry store at 8, place Vendôme, in Paris.

Since Miss Dior in 1947, Dior has maintained its tradition as a great perfumer.
J'adore perfume, 1999. © Parfums Christian Dior.

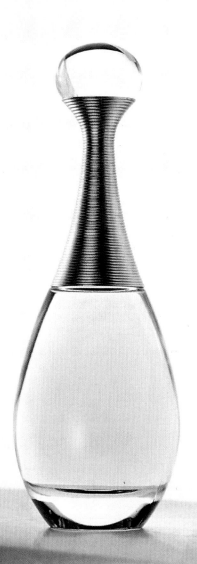

Christian Dior

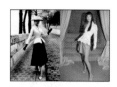

The famous "Bar" suit, keynote model of the New Look collection, February 12, 1947. © Willy Maywald/Christian Dior Archives.
The "Gallidior" suit. John Galliano goes back over the "Bar" suit for the haute couture Spring-Summer 1997 show. © Rindoff/Garcia/Angeli.

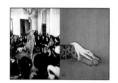

Dior's bold panther print made its first appearance in the Spring-Summer 1947 collection, in two versions : "Afrique" for the evening, and "Jungle" (here) for the day. © Bellini/Christian Dior Archives.
Advertisement for "Miss Dior." Drawing by René Gruau, 1949. The juxtaposition of a woman's hand and panther's paws refers both to Cocteau's film *Beauty and the Beast*, and to Dior's first collection. © Christian Dior Archives.

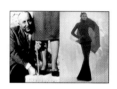

Cover of *Paris-Match*, August 1952. Dior's ironic smile anticipates the sensation he will cause when decreeing a skirt length of 16 inches off the ground. © AFP/Christian Dior Archives.
The Dior silhouette, as interpreted by John Galliano in the haute couture Summer-Spring 1999 collection. © Rindoff/Garcia/Angeli.

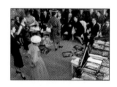

The ritual of the final rehearsal. Christian Dior and his team review the models for the haute couture Autumn-Winter 1954-1955 collection. © Walter Carone/Scoop/Paris-Match.

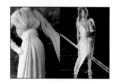

The same, but different. Draped crêpe and chiffon in the haute couture Spring-Summer 1953 collection (left: © Christian Dior Archives) and silk jersey in the haute couture Spring-Summer 2001 collection designed by John Galliano (right: © Rindoff/Garcia/Angeli).

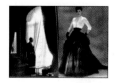

Portrait of Christian Dior by Cecil Beaton in his private mansion at boulevard Jules-Sandeau. © Cecil Beaton/Courtesy of Sotheby's, London.
A classic contrast. A simple white linen bolero relieves the full-skirted gown of draped black chiffon taffeta in the "Meilhac" model. From the haute couture Spring-Summer 1952 collection. © Christian Dior Archives.

"Gascogne." Autumn-Winter 1950. According to Dior, the dress is "an ephemeral piece of architecture designed to enhance the proportions of the female body." © Christian Dior Archives.

Advertisement for gloves, 1948. Drawing by René Gruau. Christian Dior allowed Gruau a free hand in producing his elegant, assured, and irreverent illustrations of the Dior woman. © Christian Dior Archives.

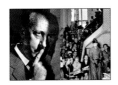

The success of the collection meant squeezing close friends in on the stairs. Dior wrote: "The clientèle I dreamed of responded to my collection. I never had to make any particular effort." © (left) Willy Maywald; (right) Christian Dior Archives/All Rights Reserved.

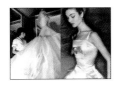

Constructing a silhouette. The dresses would not exist without the patient work of the seamstresses. © Bellini/Christian Dior Archives.

The line for Autumn-Winter 1954 is based on a full skirt and smaller bust: the slender grace of an adolescent or ballerina. © Coffin/Christian Dior Archives.

Drawing by René Gruau advertizing shoes designed by Roger Vivier for Christian Dior in 1960. © Christian Dior Archives.

Dior's models in 1957. Left to right, front, Simone, Sveltaka, Lucky, and France; second row, Olga, Catherine, and Alla; on the ladder, Renée and Victoire, whom Dior took on in spite of unanimous disapproval, and turned into a star. © L. Dean/Life Magazine/Time Warner Inc./Cosmos/Christian Dior Archives.

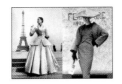

"Zémire," Autumn-Winter 1954. "H" Line. Satin evening ensemble. Jacket with "Lutetia" Emba mink. © Regina Relang/Münchner Stadtmuseum/Christian Dior Archives.

"Bleu de Perse," Autumn-Winter 1955-1956. "Y" Line. Dress and paletot in Persian blue tweed. © Regina Relang/Münchner Stadtmuseum/Christian Dior Archives.

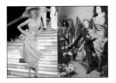

The art of drapery. "Lucitania" suit, haute couture Spring-Summer 1998 collection, designed by John Galliano (left © Rindoff/Garcia/Angeli). For Christian Dior, the ideal model was the one on whom "any dress appeared successful, so closely did her proportions match the ideal of [his] dreams." (right © Bellini/Christian Dior Archives).

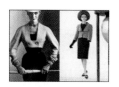

"Cachottier." Haute couture Spring-Summer 1951, "Ovale" Line. Dior superimposed three ovals : head, bust in ivory Shantung spencer, and hips, encased in anthracite gray alpaco. © Pottier/Bibliothèque nationale de France, Paris/Christian Dior Archives.

"Parc Monceau." Clean, elongated lines are the mark of this slender-fitting coat designed by Marc Bohan, haute couture Spring-Summer 1963. © J. P Cadé.

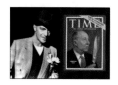

John Galliano by Peter Lindbergh. © Peter Lindbergh.

1957: the first fashion designer in the world to appear on the cover of *Time* magazine. © Rapho/Christian Dior Archives.

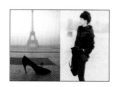

Roger Vivier's designs were shown with the main collection, and sold made-to-measure in the Boutique. For Christian Dior, in 1959, this high-heeled shoe in black suede, with its "shock" heel, was the epitome of Parisian elegance. © Cynthia Hampton.

Contemporary silhouettes. For lunch or dinner, the "Mystère de Paris" model. Haute couture Autumn-Winter 1955-1956. © Henry Clarke/Adagp, Paris 2001/Christian Dior Archives.

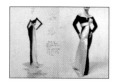

This design by Yves Saint Laurent, Dior's assistant, tells of his talent. Sketch of "Soirée de Paris" (shown left) from the haute couture Autumn-Winter 1955-1956 collection. This black velvet sheath with filled sleeves, low neck, and wide draped belt in white satin represents a change of silhouette within the same overall style. © Christian Dior Archives/All Rights Reserved.

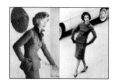

"Chantecler," Autumn-Winter 1954-1955. Two-piece suit in chiné brown tweed. In 1954, Dior abandoned the New Look; the waist was relaxed and the line softened. © Assouline.

"Balmoral," haute couture Autumn-Winter 1961-1962 collection. Dress and jacket ensemble in Chaldean brown, Prince of Wales check wool, designed by Marc Bohan. © Christian Dior Archives.

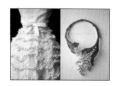

The lily of the valley, Dior's good-luck charm. Bell-shaped flowers embroidered on a dress, Spring-Summer 1957 (left: © M. Pommeré/Christian Dior Archives) and "Diorissimo" necklace: emeralds, diamonds, and pearls (right: © Florent Dumas/Art Go).

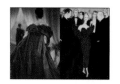

"Braise" dress by Gianfranco Ferré, haute couture Autumn-Winter 1989-1990 collection. Draped wrap in "flaming red" taffeta, trimmed with roses. © Michael O'Connor/Christian Dior Archives.

The "Ispahan" dress drawn by René Gruau for *Adam,* 1947. Pearls, gloves, stilettoes, and Dior red complete the picture. © Christian Dior Archives.

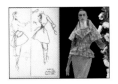

The Dior influence lives on with John Galliano. Dior's sketch for the haute couture Autumn-Winter 1950-1951 collection (left: © Christian Dior Archives) and "Princesse Bangalore" suit, haute couture Autumn-Winter 1997-1998, by John Galliano (right: © Rindoff/Garcia/Angeli).

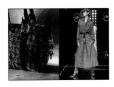

The Dior acronym. The "Vintage" bag, Spring-Summer 2001 collection, and a trenchcoat designed by John Galliano for the prêt-à-porter Autumn-Winter 2000-2001 collection. © Rindoff/Garcia/Angeli for both.

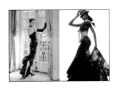

"Sirène" Line and flower prints. The classic "Baccara" dress, haute couture Spring-Summer 1957 (left: © Mile de Dulmen) and its opposite, the luxuriant and exotic "Kitu" dress created by John Galliano for the haute couture Spring-Summer 1997 collection (right: © Tyen).

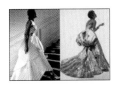

The "Verticale" Line, Spring-Summer 1950. Christian Dior gives a flowing line to his draperies, pleats, and bustles. © Willy Maywald/Christian Dior Archives.
"Jardin aux roses." Spring-Summer 1992. Gianfranco Ferré's chiné, flower-printed taffeta has a similar cascading effect. © Albert Watson/Elizabeth Watson Inc.

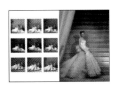

Timeless ball gowns. "Eugénie" dress, haute couture Autumn-Winter 1948-1949 collection (left: © Willy Maywald) and "Lina" dress, haute couture Spring-Summer 1997 collection, designed John Galliano (right: © Rindoff/Garcia/Angeli).

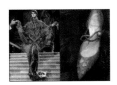

"Sheherazade." Evening ensemble created by John Galliano for the haute couture Spring-Summer 1998 collection. © Rindoff/Garcia/Angeli.
Dior loved accessories, and this shoe in printed silk by Roger Vivier shows the care lavished on such accessories at Dior. They "made" the posture. © Noelle Hoeppe.

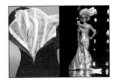

Femininity outlined by a corset. The inside of the "Atout cœur" dress, haute couture Spring Summer 1955 (left: © Sacha/All Rights Reserved) and a full-length dress from the haute couture spring-Summer 2000 collection created par John Galliano (right: © Rindoff/Garcia/Angeli).

The publisher wishes to thank the Maison Christian Dior and Katell Le Bourhis, Philippe Le Moult and Soizic Pfaff in particular for their invaluable assistance in producing this book. Thanks are due also to Angeli, Mimi Brown, Carla Bruni, Alba Clemente, Michel Comte, Lydia Cresswell-Jones, Nadège Dubospertus, Mike de Dulmen, Florence Dumas, Éditions du Regard, Giovanni Gastel, Mats Gustafson, Laziz Hamani, Cynthia Hampton, Véronique Jacqueti (Ford Paris), Mikael Jansen, Sabine Killinger (Élite), Roxanne Lowit, Jeff Manzetti, Yannick Morisot, Cathy Queen (Ford New York), Rindoff & Garcia, Sébastien Roca, Sacha, Corinna Shack, Sotheby's London, Fabienne Terwinghe, Tyen, Lucia Vietri, Albert Watson, Elizabeth Watson, and Eiser White.